Executive Editor/Seiji Horibuchi
Editors/Tsuneo Nemoto and Masaki Tokuyama (Shogakukan Inc.)
Book Design/Shinji Horibuchi
Publisher/Keizo Inoue

© Cadence Books/Shogakukan Inc., 1994
© Hiroshi Kunoh, 1994
© Eiji Takaoki & Michiru Takaoki, 1994
© Tatsuhiko Sugimoto, 1994

Distributed to the book trade by Publishers Group West

Printed in Japan

Originally published in 1994 by Shogakukan Inc. in Tokyo, Japan

First Printing, October 1994
10 9 8 7 6 5 4 3 2 1

Cadence Books
A Division of Viz Communications Inc.
P.O. Box 77010
San Francisco, California 94107

Title Page/Twin Earths by Eiji Takaoki
Endpaper Artwork by Eiji Takaoki

Photographs used to create stereogram images courtesy of:
Orion Press/Endpapers, P1, 24, 25, 33, 34, 38-39
Tsuneo Nakamura (VOLVOX)/P22
Akira Tateishi Marine Photo Library/P23

●▲■

3-D PLANET

The World as Seen Through Stereograms

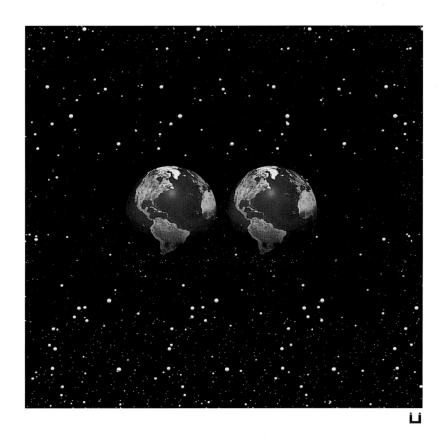

Hiroshi Kunoh & Eiji Takaoki

Cadence Books San Francisco

●

Nature

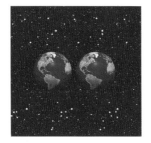

Every living creature exists only because
it has been selected for survival from among a
billion potential life sources. The existence of
every one of us is nothing less than a miracle.
To perpetuate that miracle, nearly all life
forms protect themselves by blending into their
environment through such strategies as
protective coloring and mimicry.

And yet, as life forms we have also been
provided with two (or more) eyes precisely so
that we may detect the other creatures hidden
in our environment. Two eyes are a means of
viewing the world in three dimensions.

▲

Morning Glow/Hiroshi Kunoh

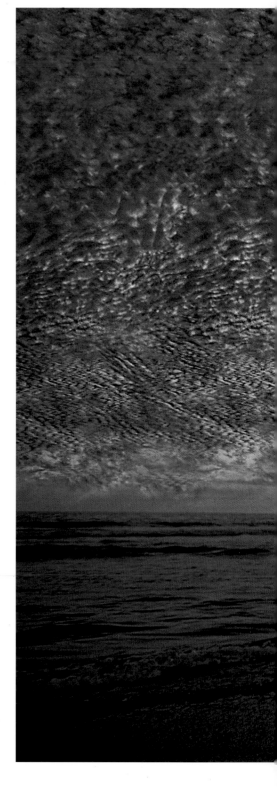

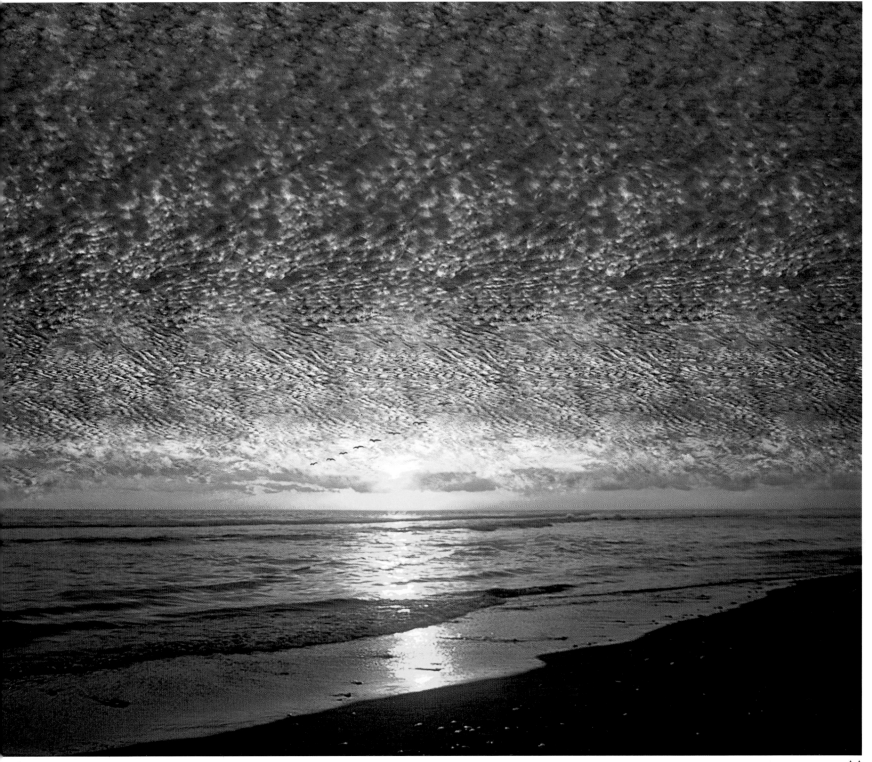

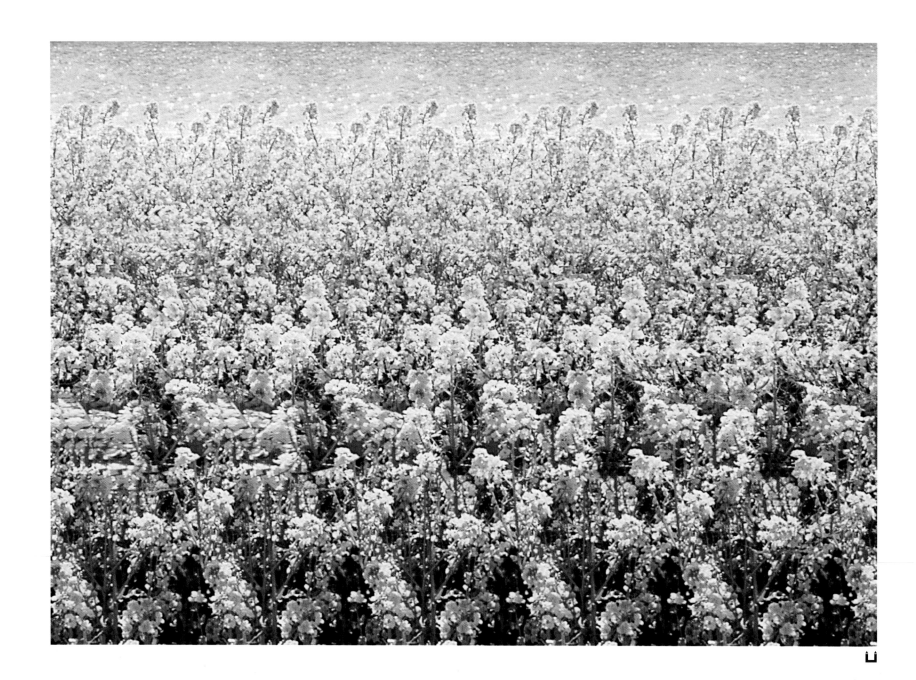

Dancing in Springtime/Hiroshi Kunoh

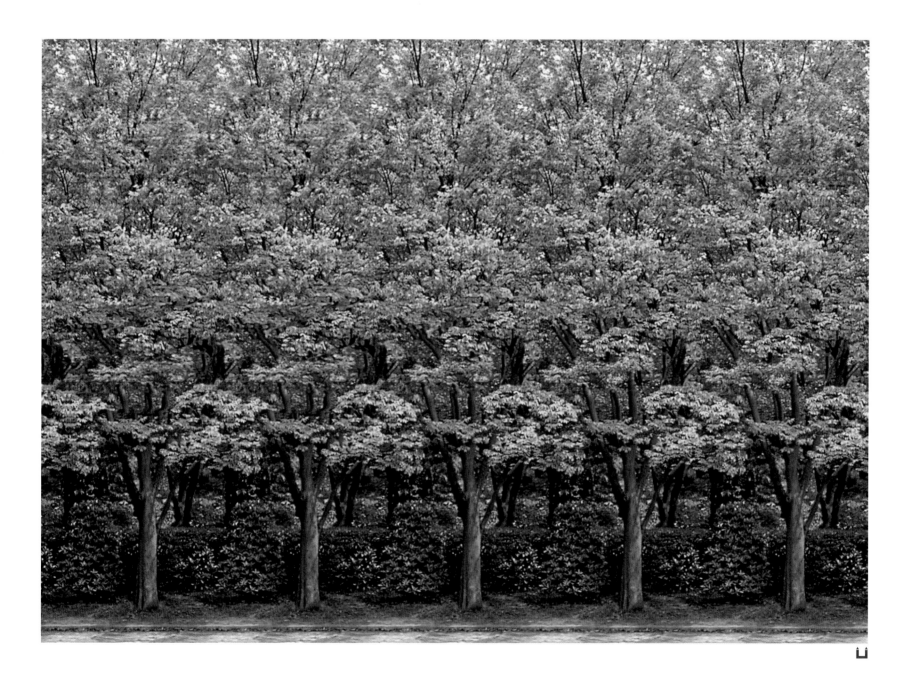

Nesting Season/Hiroshi Kunoh

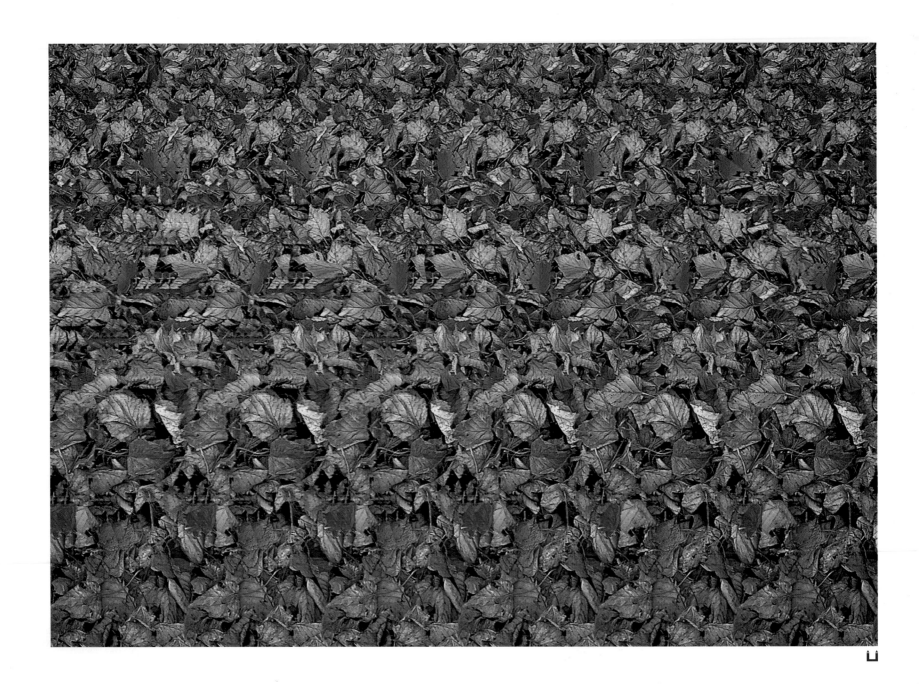

Rustling Hares/Hiroshi Kunoh

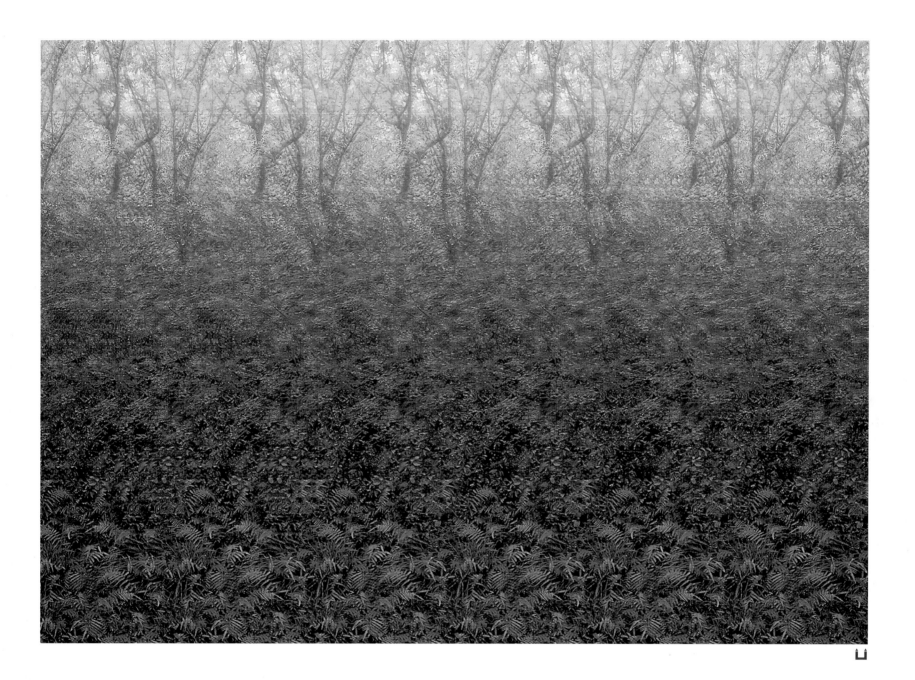

A Family Outing/Hiroshi Kunoh

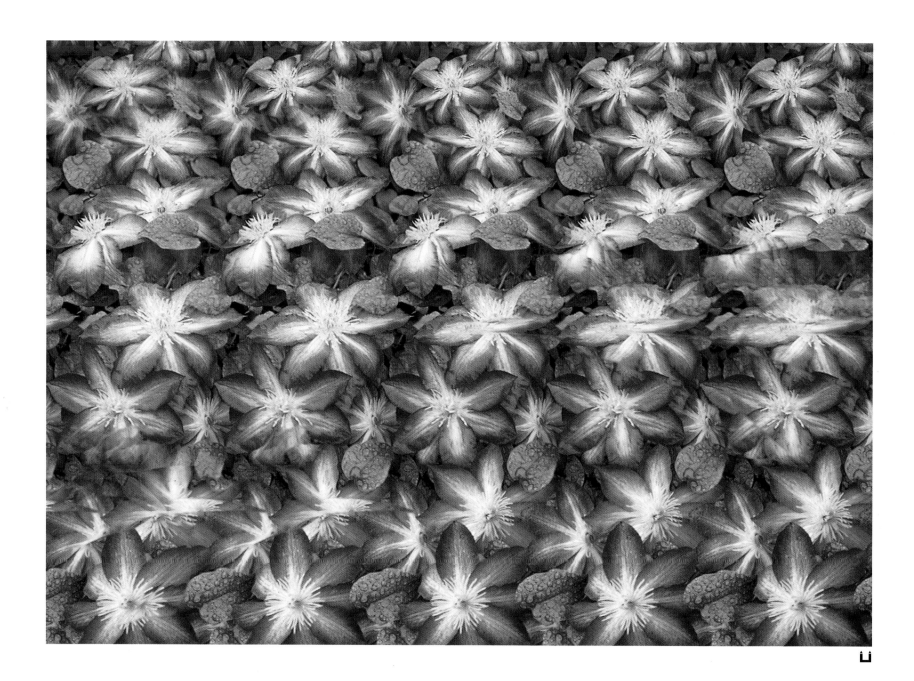

The Humming Traveler's Joy/Hiroshi Kunoh

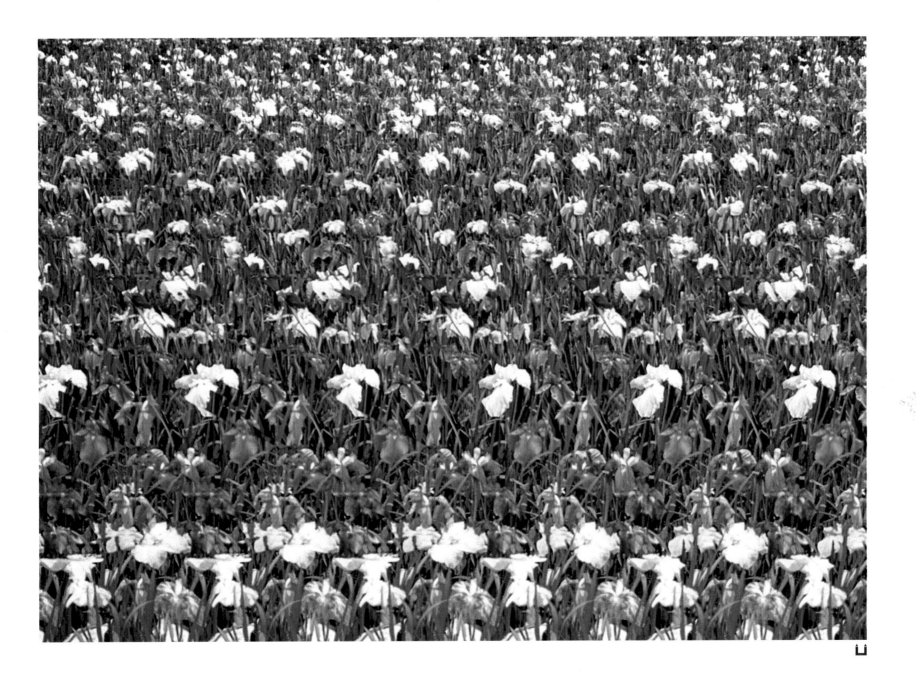

Swimming in the Deep Iris Sea/Hiroshi Kunoh

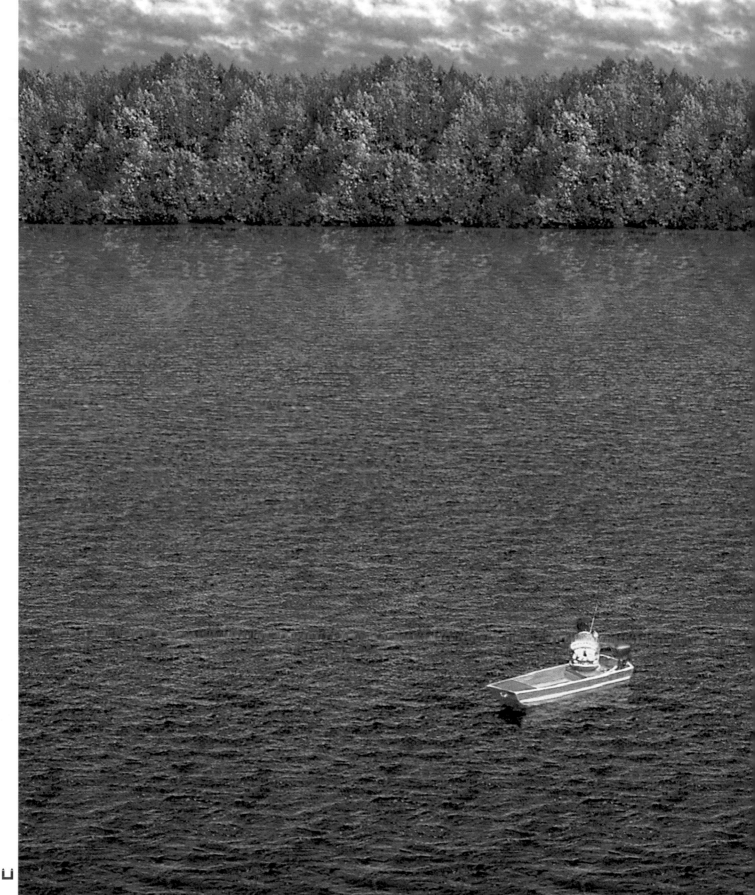

A Fisherman's Tale/
Hiroshi Kunoh

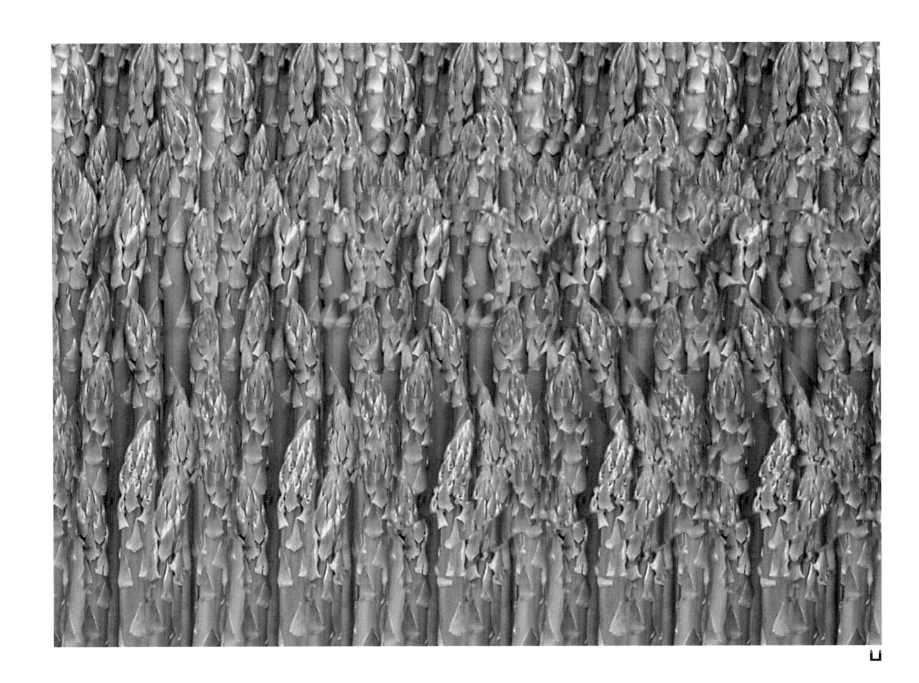

Waltzing Matilda in the Asparagus/Hiroshi Kunoh

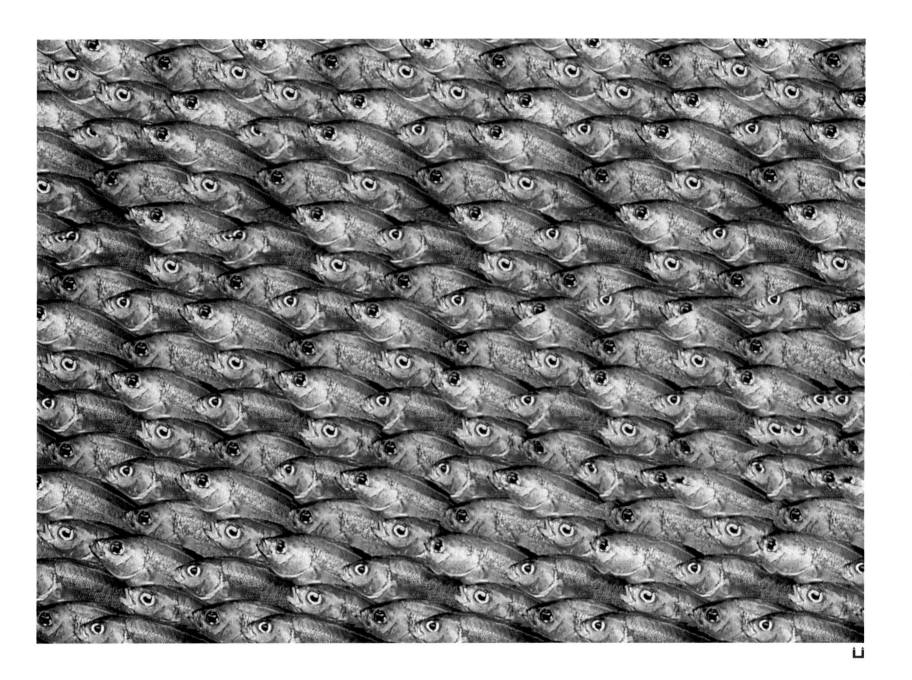

If Wishes Were Fishes.../Hiroshi Kunoh

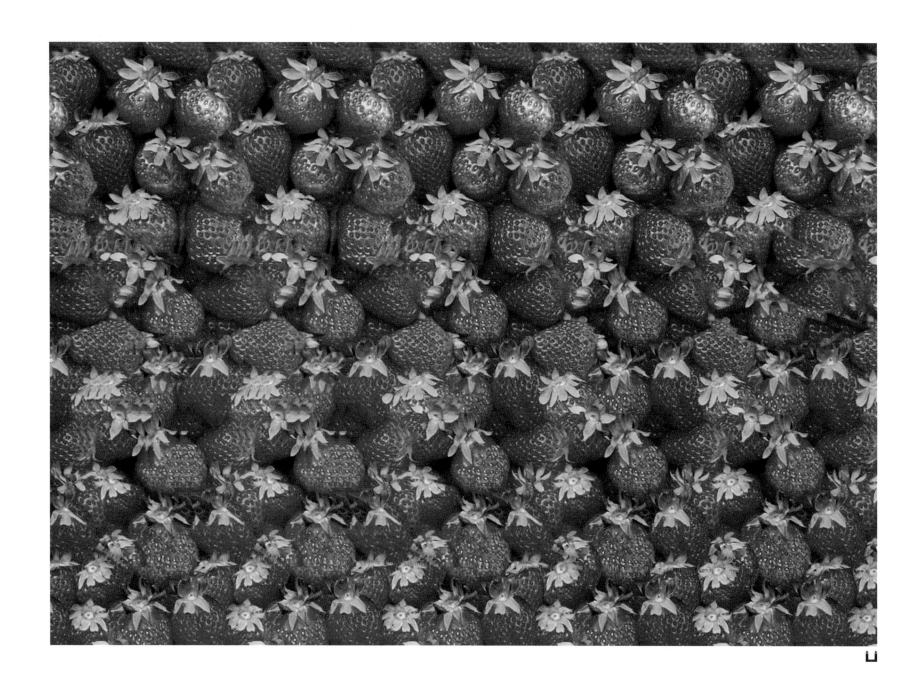

Strawberry Bisque/Hiroshi Kunoh

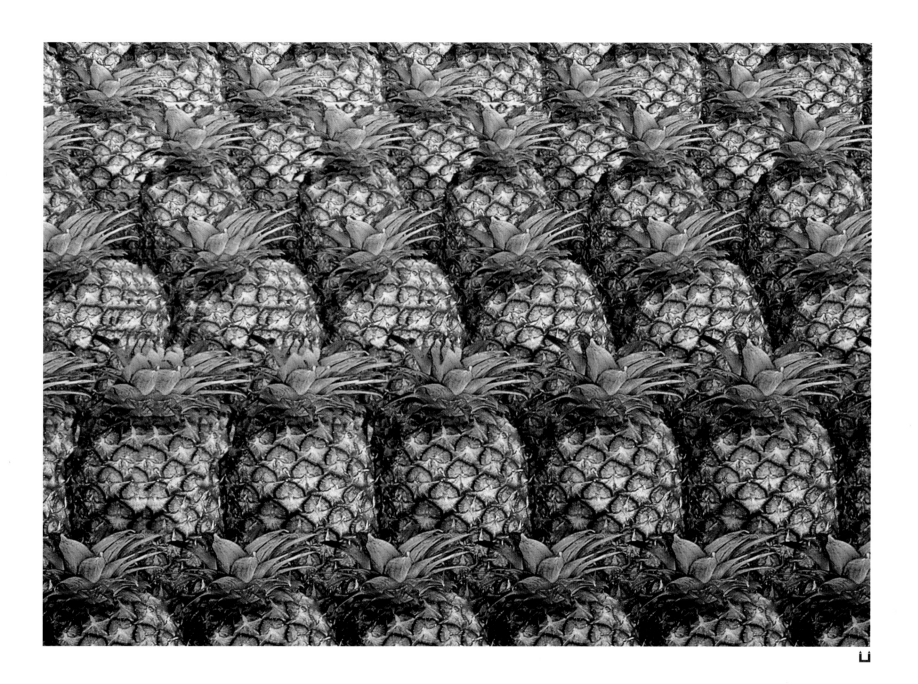

Pining for the Swamps/Hiroshi Kunoh

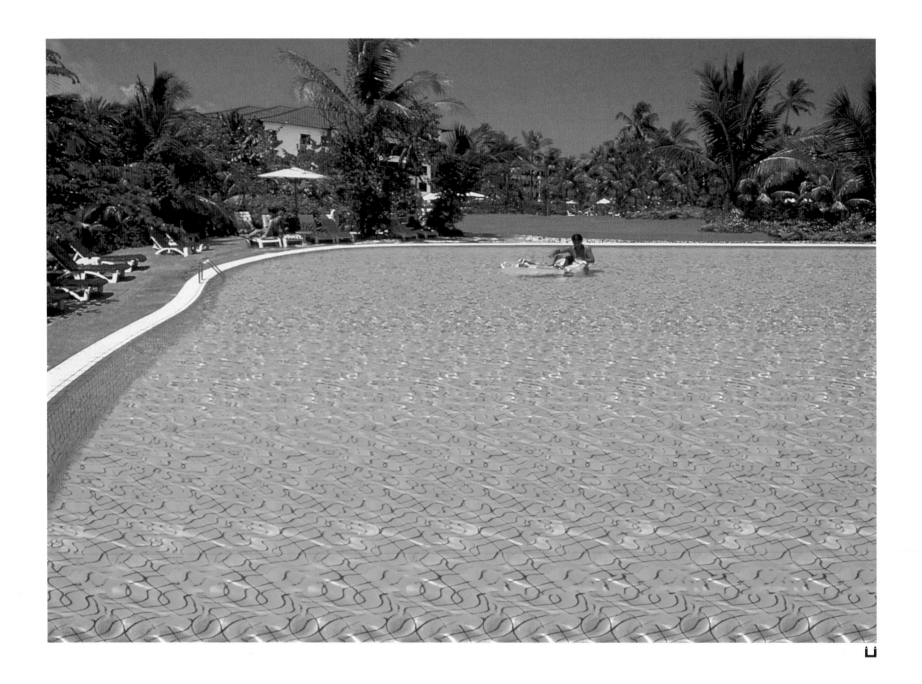

Too Chilling to Swim/Hiroshi Kunoh

Afternoon Grazing/Hiroshi Kunoh

Creatures

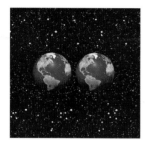

The ability to blend into the environment,
and the use of two eyes to detect others—
both are crucial means to an end for the
survival of every living creature.

Since life first appeared some 3.5 billion
years ago, every species has expended vast
amounts of energy in the contest for survival.
The process of renewal and replacement is
never-ending. Mankind calls this "evolution,"
yet at every important stage in the process
of renewal, every species has also been
haunted by the specter of extinction.

Diplodocus in the Late Jurassic/
Tatsuhiko Sugimoto
(Special Contributor)
Use the cross-eyed method to view this work.

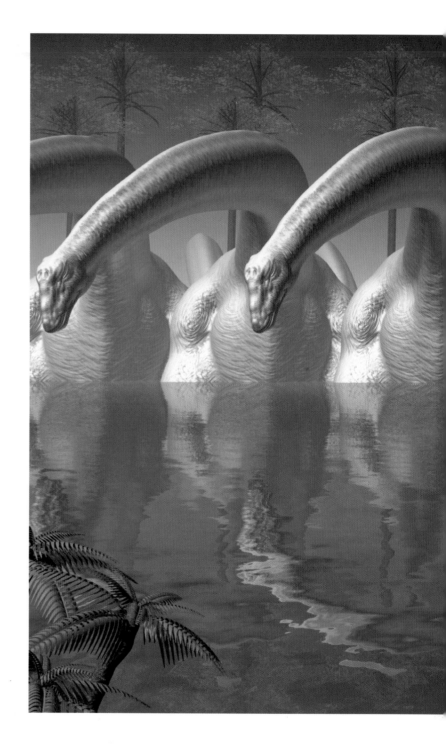

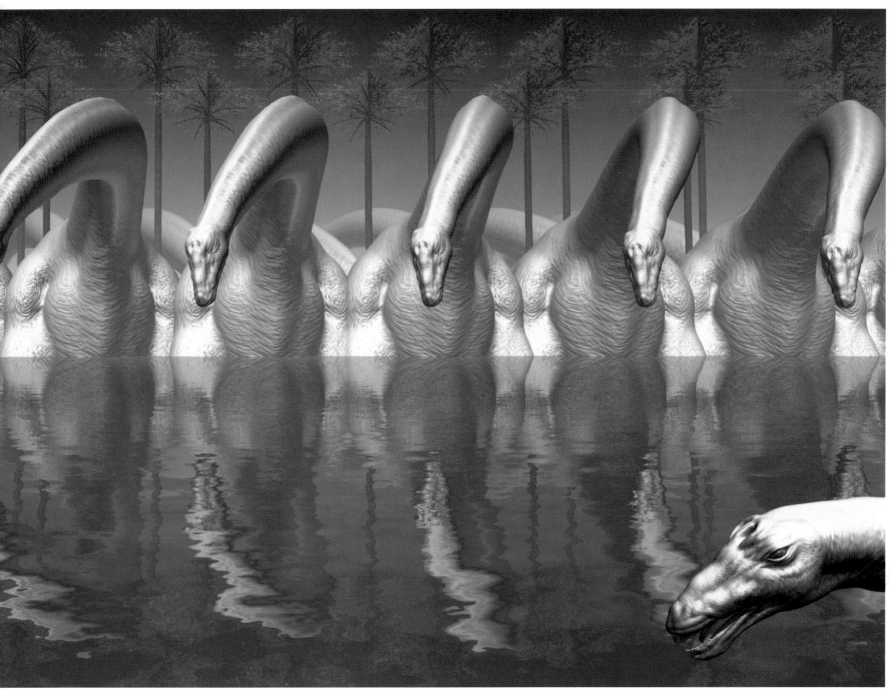

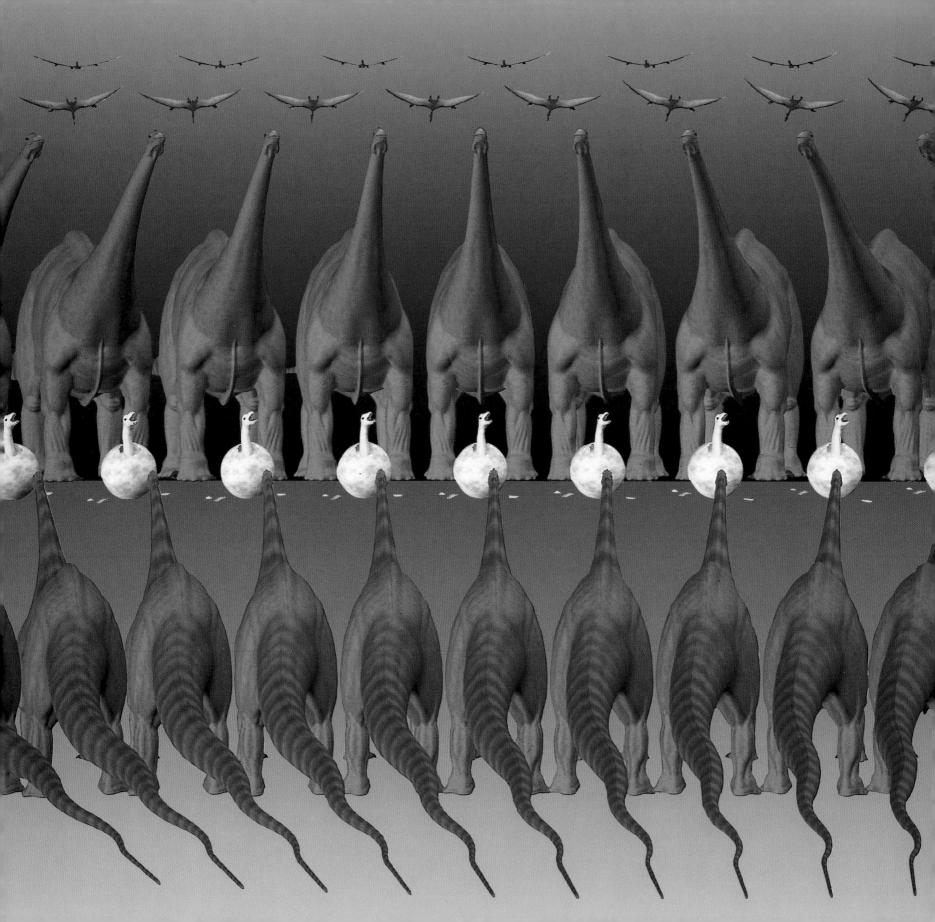

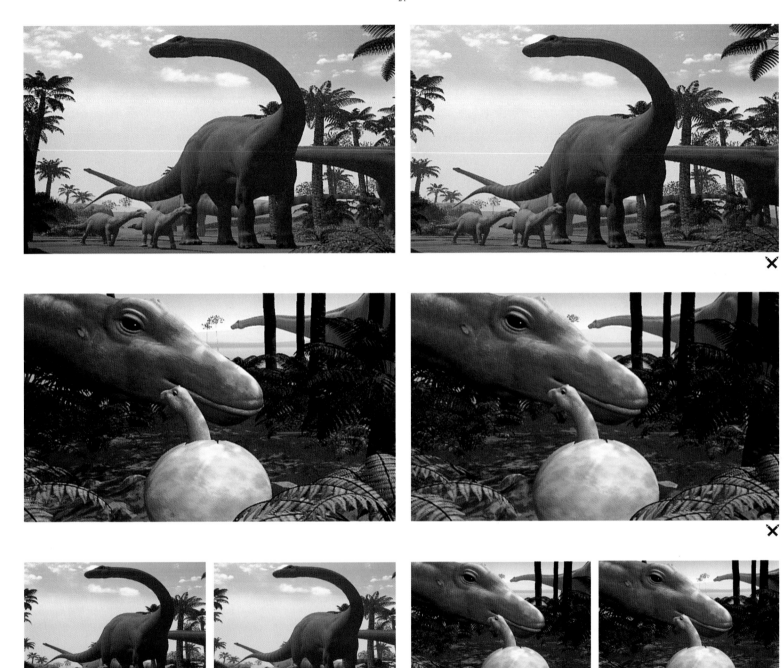

Left Page
The Birth of Baby Alamosaurus/Michiru Takaoki

On This Page
Cretaceous Family/Michiru Takaoki
Use the cross-eyed method to view the top and middle stereo pairs,
and the parallel method to view the stereo pairs at the bottom.
(From the computer-graphics animation, *The Lost Animals*)

Nautilus / Eiji Takaoki

This cephalopod chose not to abandon its shell. To this day, it lives in the
deepest seas, as if refusing to participate in the evolutionary process.

Living Fossil/Eiji Takaoki
The legendary coelacanth,
spotted here in the deep seas off Madagascar.

Photo © Orion Press

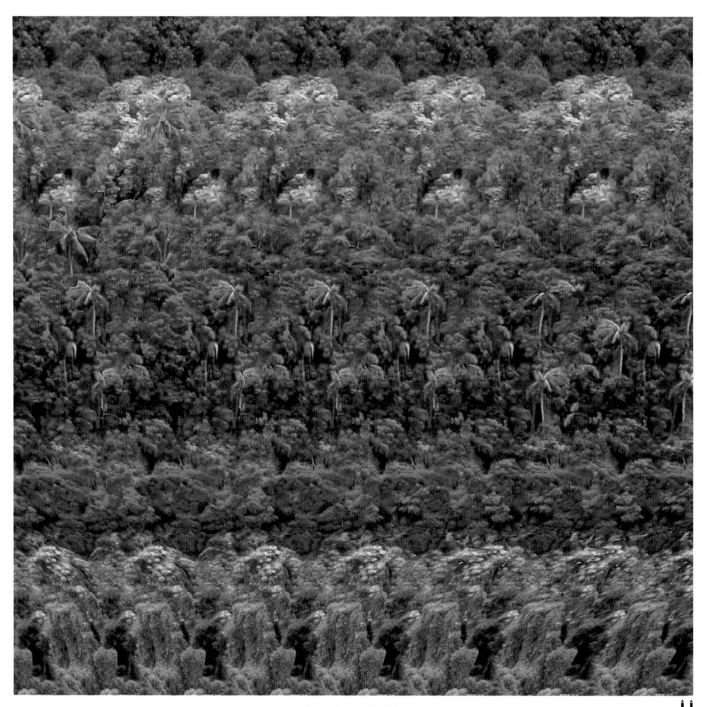

Dodo/Eiji Takaoki

This turkey-sized relative of the pigeon became extinct
because humans hunted it for food.

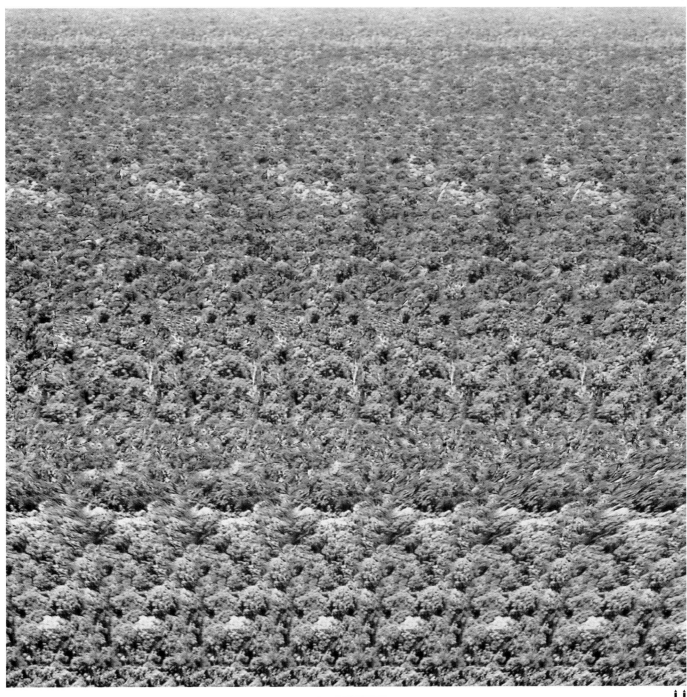

Elephant Tortoises/Eiji Takaoki
Once a favorite food for sailors visiting the Galápagos Islands,
the elephant tortoise is in danger of becoming extinct.

Photo © Iwago Photographic Office

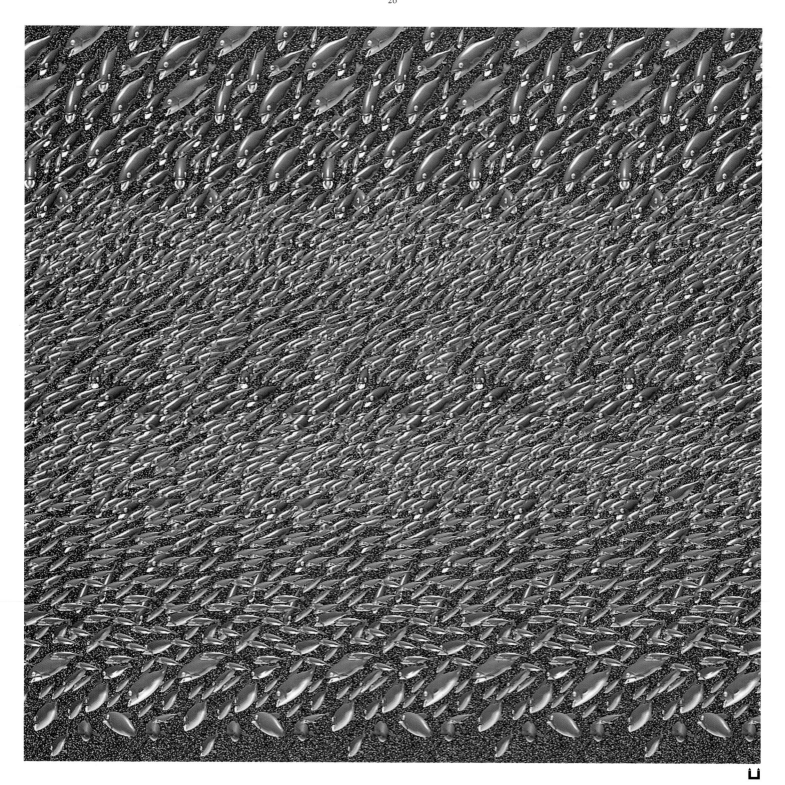

Eating and Being Eaten/Michiru Takaoki
(Special Contributor)

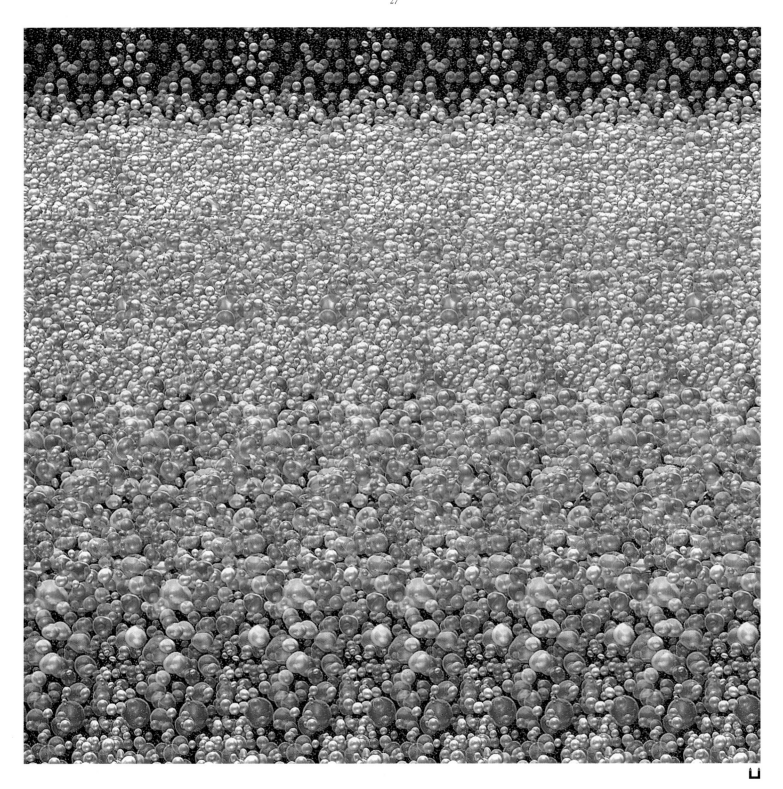

An Evolutionary Step?/Michiru Takaoki
(Special Contributor)

Mankind

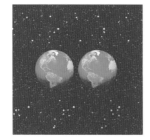

Where is the link between the instant when life was born billions of years ago and the present, if not in mankind? Our DNA carries the record of those 3.5 billion years for us, but we have yet to fully grasp the sophistication and subtlety of the design of the life form known as *Homo sapiens*—a design found in the genome of our DNA.

The three-dimensional effect is created by the superimposition of the different images seen by our right and left eyes. Our ability to produce this phenomenon on paper through computer technology may give us a hint as to the exquisite complexity of the human life form.

●

DNA/Eiji Takaoki
The double helix of DNA embraces several spherical nucleosome cores which consist of proteins called histone. That so much genetic information can be stored so compactly in such an elegant form is truly a thing of wonder.
(Be sure to view this work using the cross-eyed method.)

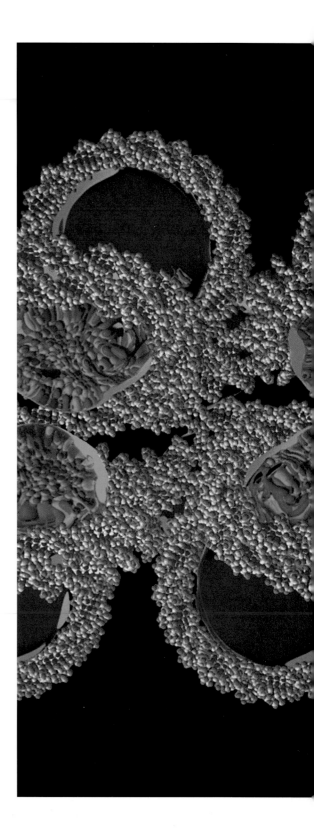

DNA 2 / Eiji Takaoki

By rotating this image into a vertical position, you can view it with the cross-eyed as well as parallel method.

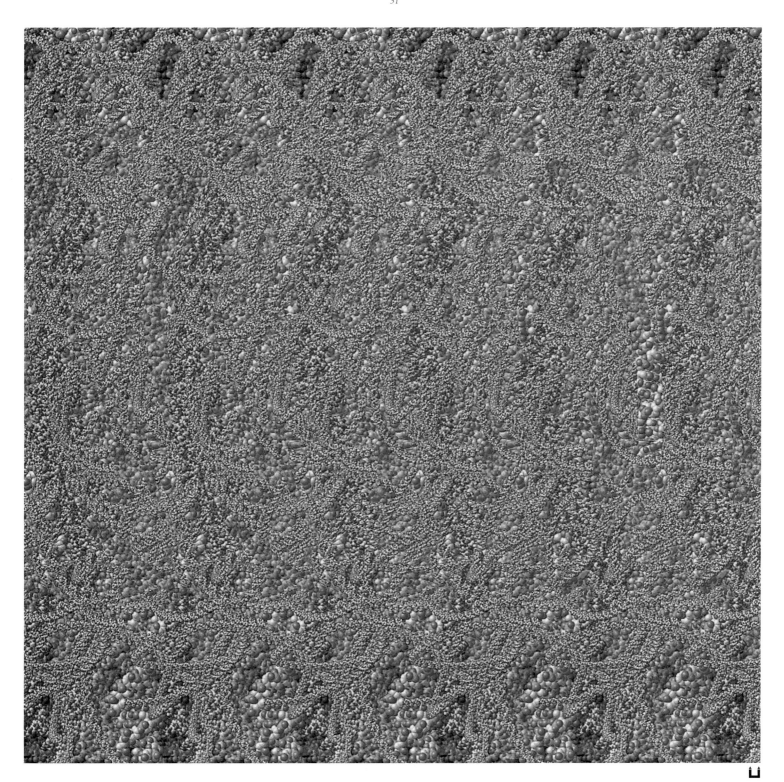

Birth Place/Eiji Takaoki

Can you remember those floating, dreaming days?

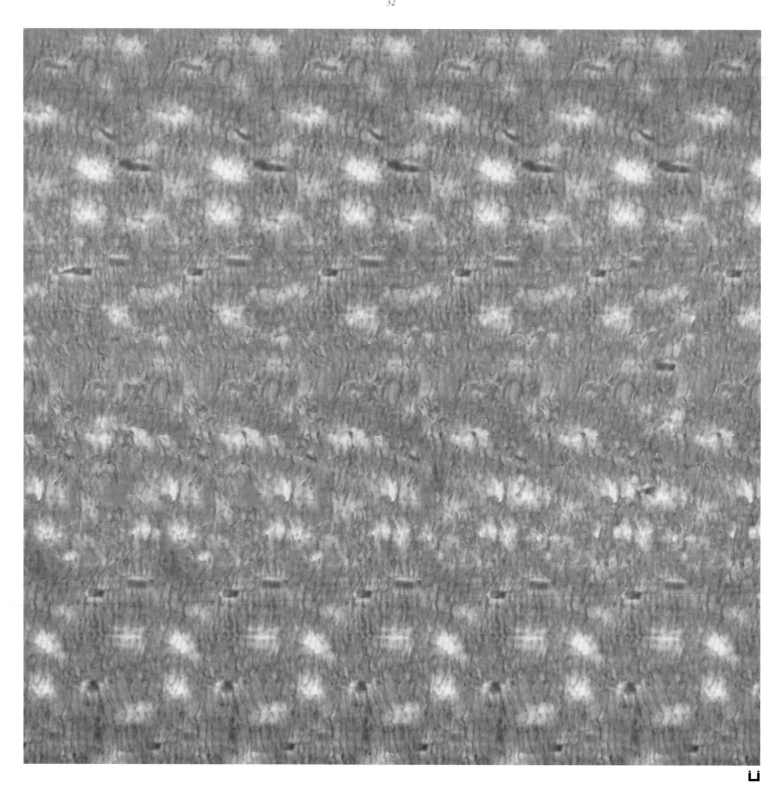

Cradle of Civilization/Eiji Takaoki

Your mother's pelvis was your very first cradle. A microphotograph of bone tissue is used to form this image.

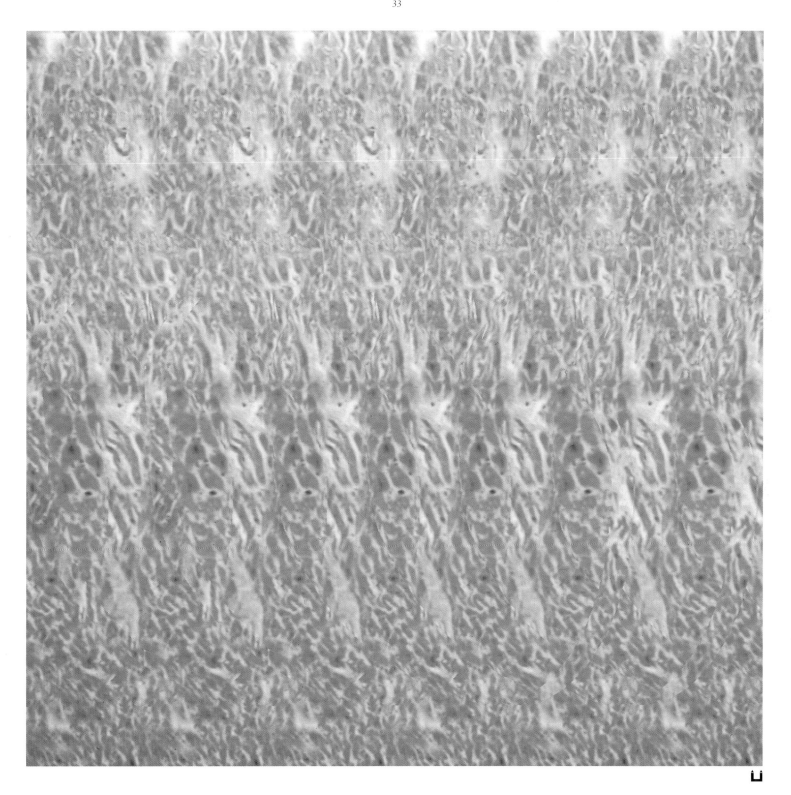

Heartbeat/Eiji Takaoki

A microphotograph of heart muscle is used here.

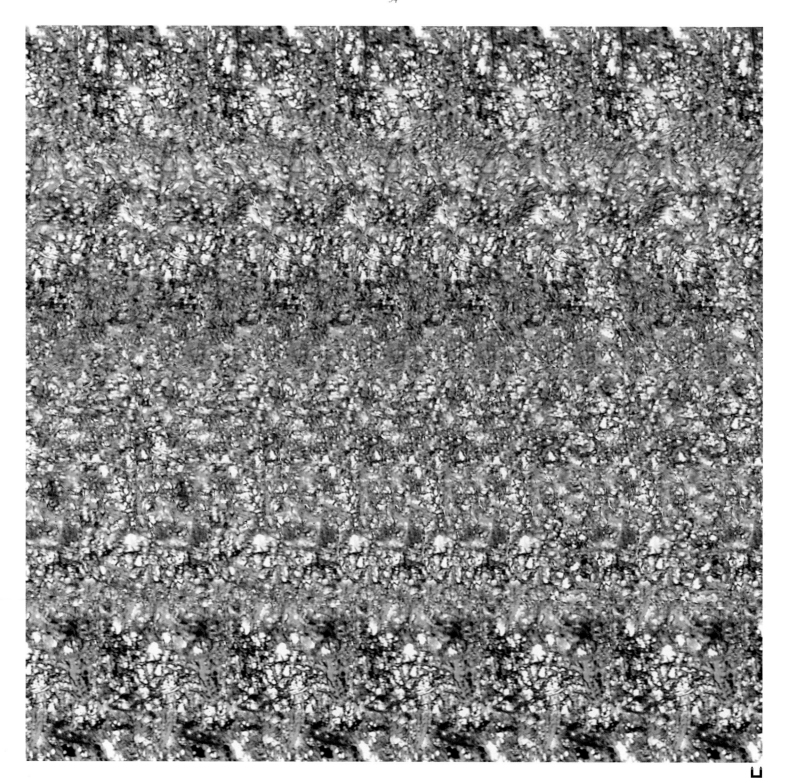

The Stranger in You/Eiji Takaoki

A mineral is microphotographed and employed to create this image.

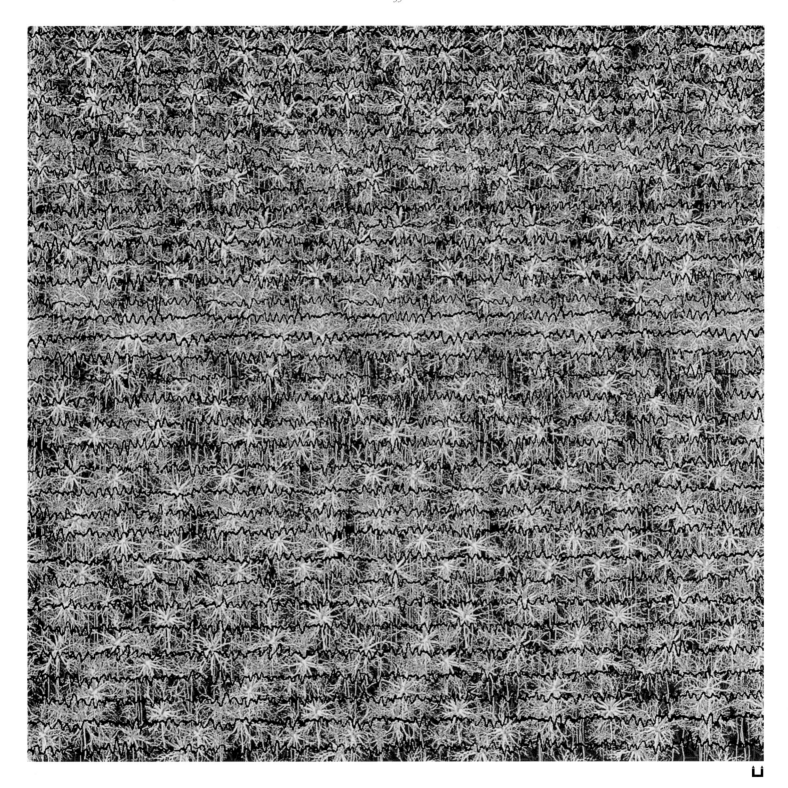

Self-Image/Eiji Takaoki
Look beyond the face (rendered by an electroencephalograph or EEG) to see your brain and eyeballs.

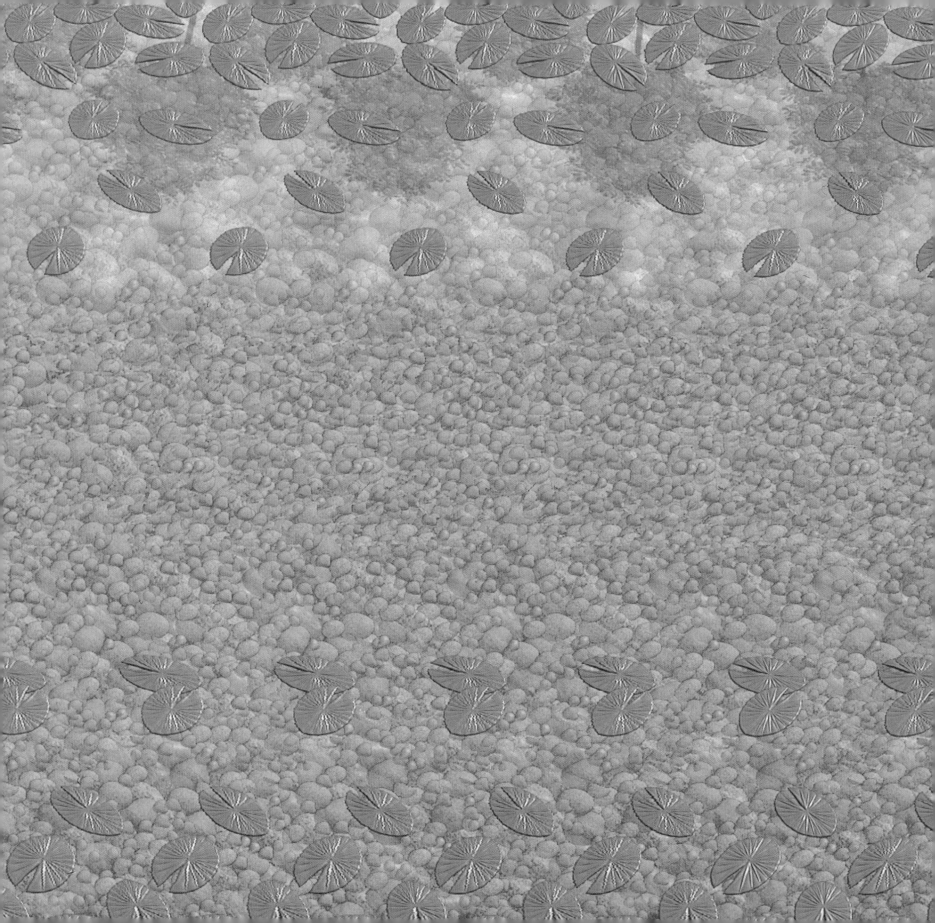

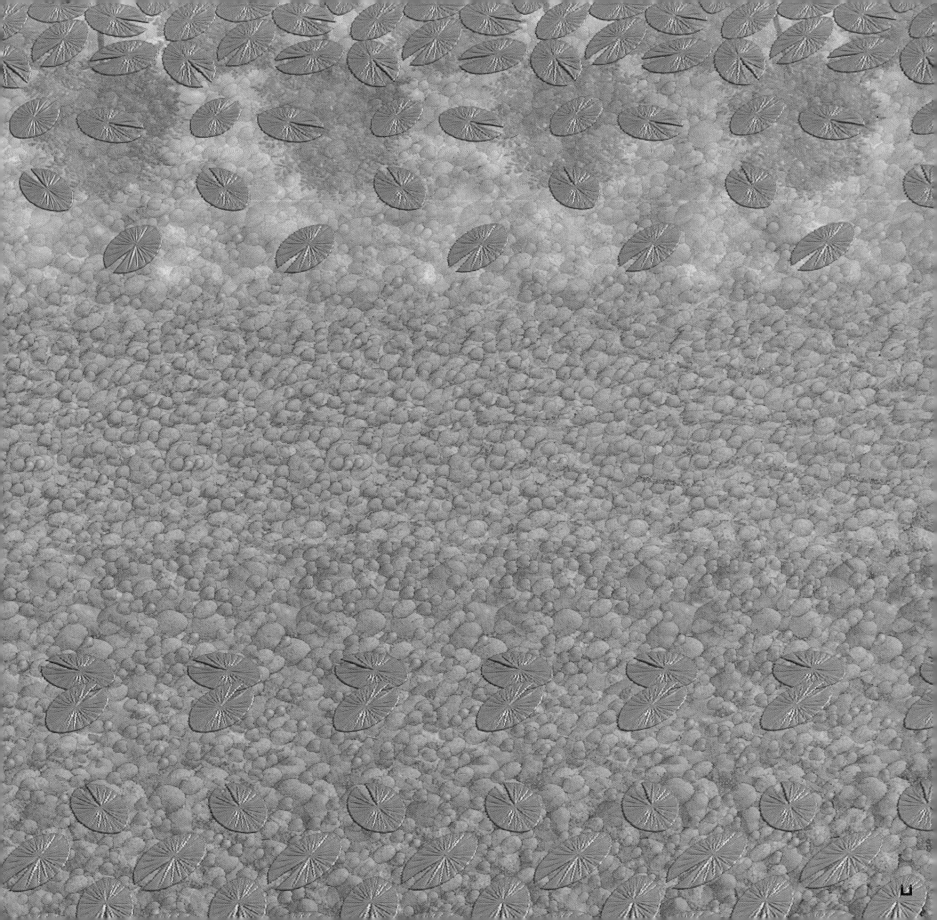

P36-P37

Ophelia / Eiji Takaoki

P38-P39

Return to Earth / Eiji Takaoki

On This Page

Return to Life / Eiji Takaoki

And so the life cycle continues.

HIROSHI KUNOH

Hiroshi Kunoh was born in 1948. After majoring in photography in college, he spent many years as manager of a commercial photography studio. He began working with computers in 1990 and went on to create computer graphics, primarily for advertising media, at the Technica Corporation. Inspired by the work of Eiji Takaoki, he began developing his own photograph-based stereogram techniques in 1993.

"To someone coming from a background in photography, as I have, the computer is like an ideal camera. For the past ten years, I've been interested in 'taking' pictures that can't be shot with an ordinary camera and silver halide film. When I started out doing computer graphics on a Macintosh, my first works were images of glass and metal floating in space—something you can't easily get on film. I call the computer an ideal camera because it allows you to represent unreal objects or environments as if they were real. 'Filming' with a computer became my main vocation.

"As I continued my efforts to portray unreal realities, I became interested in the question of how human beings distinguish between what is a photograph, what is a picture, and what is real. I wanted to create works that utilize visual perception and cognition, as well as illusion.

"A stereogram creates a mysterious space, produces sensations that can't be expressed through a flat surface alone. I intend to continue creating works that give the viewer pleasure in this way."

EIJI TAKAOKI

Born in 1951, Eiji Takaoki devoted himself to figurative sculpture from an early age. In university, he studied behavioral science, physiology, oriental medicine, and electronics. In 1986, he developed MetaEditor, modeling software designed to utilize 3-D primitives called "metaballs," known for their powerful ability to model complex organic shapes. He is currently president of META Corporation Japan, a software development company.

"My consuming interests have always been human beings and the human body. It's my belief that we can never delve deeply enough in our examination of the human species. Through my studies of behavioral science, psychology, oriental medicine, and figurative sculpture, I have tried to look at humanity from many different perspectives. Computer graphics is just one of my methods for pursuing this goal, as well as a means of expressing my own views. The process of modeling and reconstructing an object is a tremendous aid to the understanding of that object.

"But computer graphics is not yet a mature technology. To express things that cannot be expressed through existing computer graphics technology, we are forced to develop entirely new techniques. The stereograms in this book required the development of new software, for example. As I see it, my most important task is to influence society, not only through my work, but by the development and marketing of new computer graphics software."

Special Contributors:
Tatsuhiko Sugimoto and Michiru Takaoki